THE PHANTOM MENACE ™

Packed with non-stop action,

MIGHTY CHRONICLES™

are the little books with the big punch.
Look for other titles in
this exciting series, including

Star Wars®, The Empire Strikes Back™, Return of the Jedi™,
Hercules: The Legendary Journeys™, Xena: Warrior Princess™,
The Lost World™, The Mask of Zorro™,
Raiders of the Lost Ark™, Terminator™ 2

Collect them all!

STAR WARS®

EPISODE I
THE PHANTOM MENACE™

Based on the story & screenplay by George Lucas
Adapted by John Whitman
Illustrated by Brandon McKinney

CHRONICLE BOOKS
SAN FRANCISCO

Visit the official *Star Wars* Web site at: www.starwars.com

Printed in Hong Kong

A First Street Films Book

Composition by Margery Cantor

Library of Congress Cataloging-in-Publication Data available.
ISBN: 0-8118-2315-6

Distributed in Canada by Raincoast Books
8680 Cambie Street
Vancouver, BC V6P 6M9

10 9 8 7 6 5 4 3 2

Chronicle Books
85 Second Street
San Francisco, CA 94105

www.chroniclebooks.com

A
LONG TIME
AGO IN A
GALAXY
FAR, FAR
AWAY

As Federation battleships hovered over Naboo, a small Republic cruiser streaked toward the flagship of the armada. On the bridge of the cruiser, the ship's captain was negotiating with the commander of the Trade Federation's fleet.

The image of Viceroy Nute Gunray, a Neimoidian, filled the screen. "With all due respect for the Trade

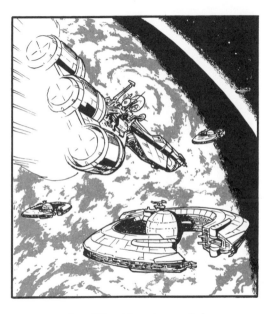

A small Republic cruiser streaked
toward the flagship of the armada.

Federation," the captain said, "the ambassadors for the Supreme Chancellor wish to board immediately."

Viceroy Gunray coughed nervously. "Yes, yes, of course . . . ah . . . as you know, our blockade is perfectly legal, and we'd be happy to receive the ambassadors. Happy to."

The image of the Neimoidian vanished, replaced by a view of the

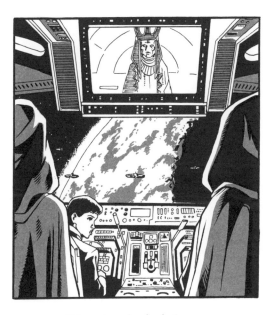

"The ambassadors for the Supreme Chancellor wish to board immediately."

looming battleship. The mouth of the warship's docking bay yawned wide, and a moment later it had swallowed the smaller craft.

※ Two cloaked figures left the cruiser and were shown to a conference room aboard the Federation vessel.

The older one sat calmly, his clear eyes gazing out of a viewport toward the green planet below. His name was

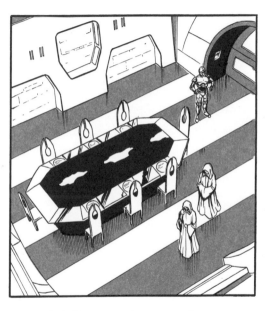

Two cloaked figures were shown to a conference room.

Qui-Gon Jinn, and he was a Jedi. In fifty years he had learned a great many things, including patience.

His young apprentice had not. Obi-Wan Kenobi stood and paced. "I have a bad feeling about this."

Qui-Gon shrugged. "I don't sense anything."

Young Obi-Wan frowned. "It's not

"I have a bad feeling about this."

about the mission, Master. It's some-
thing . . . elsewhere . . . elusive."

"Don't center on your anxiety,
Obi-Wan. Keep your concentration
here and now, where it belongs."

The younger Jedi nodded. "How
do you think this trade viceroy will
deal with the Chancellor's demands?"

"These Federation types are cow-
ards. The negotiations will be short."

—✳—

✳ Meanwhile, on the bridge of the battleship, Nute Gunray and two other Neimoidians, Daultay Dofine and Rune Haako, had just learned that the Republic ambassadors were Jedi Knights.

Dofine started to panic. "Blind me, we're done for!"

Nute replied, "Stay calm! I'll wager the Senate isn't aware of the Supreme

Chancellor's moves here. I'll contact Lord Sidious."

Nute activated communications, and soon a holographic image appeared of a figure wrapped in a dark cloak, its face concealed by a hood. "What is it?"

As Nute informed the figure of their visitors, Dofine burst in, "This scheme of yours has failed, Lord

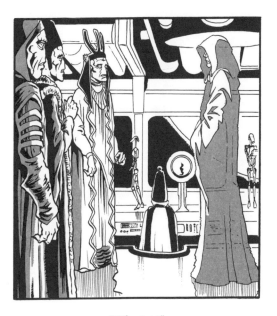

"What is it?"

Sidious! The blockade is finished! We dare not go against these Jedi."

From the shadows of his cloak, Sidious glared. "You seem more worried about the Jedi than you are about me, Dofine."

Daunted by Lord Sidious's glare, the nervous Neimoidian stepped back. Sidious addressed Nute. "This turn of events is unfortunate. We must

"The blockade is finished!
We dare not go against these Jedi."

accelerate our plans. Begin landing your troops."

Nute hesitated. "And . . . the Jedi?"

Lord Sidious replied, "Kill them, immediately."

✳— In the docking bay of the warship, a gun turret swung around and pointed directly at the Republic cruiser. Inside, the captain and a pilot noticed the movement.

"Kill them, immediately."

The pilot's face went white. "Captain, look!"

"No!" the captain yelled. "Shields up!" But her last order was drowned out by a burst of laser fire and a thunderous explosion as she and her ship were vaporized.

✳ In the conference room, the two Jedi felt ripples of panic reach them through the Force. Instantly they were

The captain and her ship were vaporized.

on their feet, their lightsabers drawn. For a moment nothing happened. Then a faint hissing reached their ears.

"Gas!" Qui-Gon said. Each Jedi took a quick, deep breath, and waited.

✳︎ A squad of Trade Federation battle droids marched to the conference room and opened the door, releasing a cloud of green gas into the hallway. Suddenly, two lightsabers appeared

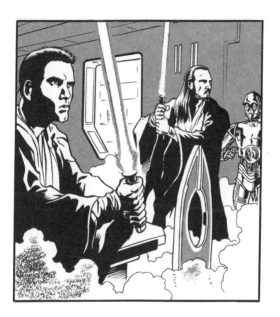

"Gas!"

inside the gas cloud, slashing down at the battle droids. Four were cut in half before the rest could open fire.

The Jedi battled their way past the droids until they reached the door to the bridge. Massive blast doors dropped down to block their path. Qui-Gon began to cut through the doors—when Obi-Wan sensed something through the Force.

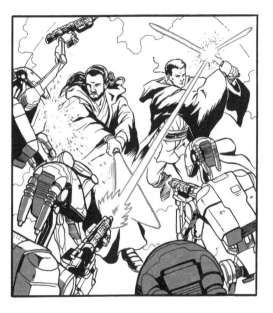

The Jedi battled their way past the droids.

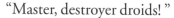
"Master, destroyer droids!"

Just then ten murderous wheel-shaped droids rolled down the hallway. At the last moment, the wheel-droids stopped. With a whir of hydraulics they transformed into battle-mode and opened fire.

But the Jedi had vanished.

Qui-Gon and Obi-Wan crawled through a large vent that emptied into

a massive hangar bay. Pausing at the edge of the vent, they watched thousands of battle droids being loaded onto landing craft.

"It's an invasion army," Obi-Wan noted.

Qui-Gon furrowed his brow. "It's an odd play for the Trade Federation. We've got to warn the Naboo and contact Chancellor Valorum."

Obi-Wan wryly smiled. "You were right about one thing, Master. The negotiations were short."

✳ Trade Federation ships packed with battle droids dropped out of the skies like a swarm of angry insects, coming to land in the midst of a thick swamp. As the battle droids disembarked, Qui-Gon slipped quietly into the cover of the mist-shrouded marsh.

*Trade Federation ships dropped out of
the skies like a swarm of angry insects.*

He crept through the damp under-brush, trying to estimate the number of enemy vessels.

Suddenly, the launch bay doors of the assault ships opened, and dozens of transports emerged. Their engines roared to life and they shot forward, scattering scores of creatures of all description.

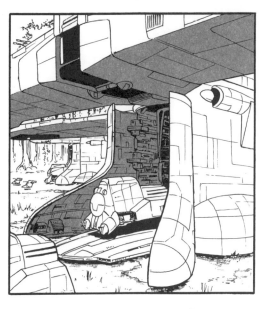

Dozens of transports emerged.

Qui-Gon ran for cover, straight into a long-eared, gangly creature that had been munching on a clam by the side of a pool. Startled by the noise, the long-eared creature jumped to its feet, its awkward limbs splayed out. A stampede was heading right toward it!

"Oh, no!" it shouted, clutching at Qui-Gon. "Hey, hep me! Hep me!"

Qui-Gon ran for cover.

"Let go!" the Jedi growled, but the gangly native ignored him and clung more tightly to his clothes.

A deafening roar filled their ears, and Qui-Gon whirled—the troop transport was right on top of them. Instinctively, he dropped to the ground, covering the creature. They planted themselves flat into the mud as the huge warship thundered overhead.

The troop transport was right on top of them.

As the warship disappeared in the mist, the creature leaped to its feet and wrapped Qui-Gon in a muddy hug.

"Oyi, mooie-mooie. I luv yous!" The creature danced around and continued to speak in his strange version of the Basic language of the galaxy. "Mesa culled Jar Jar Binks. Mesa yous humbule servaunt!"

"Mesa culled Jar Jar Binks."

Qui-Gon frowned. "That won't be necessary."

"Oh, boot tis! Tis demunded byda guds. Tis a life debt."

Suddenly Obi-Wan ran toward them from the woods, chased by a droid on a flying platform, firing laser blasts at the young Jedi. Qui-Gon ignited his lightsaber and deftly blocked the shots, ricocheting them

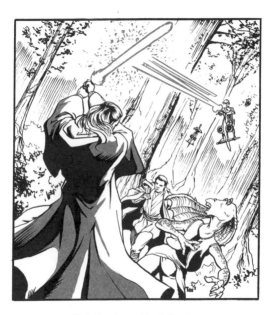

Qui-Gon ignited his lightsaber.

back and destroying the droid. Obi-Wan looked at the curious creature beside them. "What's this?"

"A local," Qui-Gon explained. "Let's go, before more of those droids show up."

"Ex-squeezeme," Jar Jar said. "But da moto grande safe place would be Otoh Gunga. Tis where I grew up . . . Tis the Gungans' home. Tis safe city."

Qui-Gon was intrigued. "Can you take us there?"

"Uh . . . well . . . no, not really. My afraid my've bean banished. Der bosses would do terrible tings to my if me goen back dare."

Qui-Gon jabbed a finger at the mist-shrouded forest, where the sound of war machines could be heard growing louder by the moment. "Do you

hear that? That's the sound of a thou-
sand terrible things heading this way."

Jar Jar gulped. "Yousa point is well
seen. Dis way!"

The lanky Gungan led them to the
edge of a murky lake. He started to
wade in, then turned to his two
human companions. "Um . . . wesa
goen underater, okeyday?"

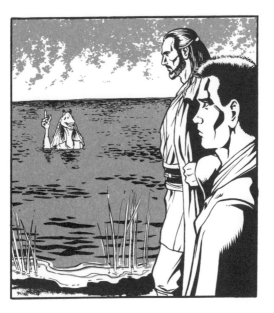

"Um . . . wesa goen underater, okeyday?"

The two Jedi pulled capsules from their belts, breathing devices they held between their teeth. Following Jar Jar, they plunged into the cold lake water.

The Gungan seemed more at home in the water than on land. Relaxing, Qui-Gon let the Force guide him, swimming quickly with as little effort as possible. Even so, several

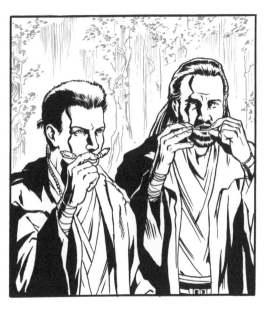

The two Jedi held breathing devices between their teeth.

times Jar Jar had to stop and wait for them to catch up. Then he would turn and swim deeper into the dark water.

Eventually, the darkness was broken by a distant light. Jar Jar swam straight toward it, and the light grew larger, evolving into a cluster of huge glowing domes that wimpled slightly like membranes. With hardly a pause, Jar Jar swam directly into one of the

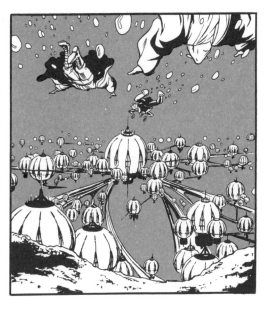

A cluster of huge glowing domes wimpled
slightly like membranes.

membranes, which sealed behind him instantly. The two Jedi followed close behind, and found themselves stepping out of the water and onto the streets of a city.

Their appearance startled a number of Gungans, who shouted in alarm and scattered. Almost immediately, four armed Gungans appeared, riding on the backs of trotting kaadu. Their

leader lowered an electropole threateningly.

Jar Jar put on his best smile. "Heyodalee, Cap'n Tarpals. Mesa back!"

The lead Gungan groaned. "Noah gain, Jar Jar. Yousa goen tada bosses. Yousa in big dudu dis time."

The Gungan guards moved forward menacingly, but the Jedi did not resist. They were being taken to the

city leaders, which was exactly what they wanted.

The three captives were led to a high tower in the center of Otoh Gunga. Through the window, they could see the top of the water dome just a few meters above them. Inside the room, in a semi-circle, sat a row of important-looking Gungans. In the center of the circle sat Boss Nass, a fat

In the center of the circle sat Boss Nass.

Gungan with a sour look on his face.

Jar Jar was held off to one side while the bosses heard the two Jedi speak. Qui-Gon told them of the invading army of battle droids.

Boss Nass shook his head and gurgled, "Yousa cannot bees hair. Dis army of Mackineeks up dare tis new weesongda reason!"

Qui-Gon spoke up. "That droid

"Yousa cannot bees hair."

army is about to attack the Naboo. We must warn them."

Boss Nass spat. "Wesa no like da Naboo! Da Naboo tink day so smarty. Day tink day brains so big."

Obi-Wan added, "Once those droids take control of the surface, they will come here and take control of you."

Boss Nass could not be swayed. "Wesa wish no nutten in yousa tings,

"Once those droids take control of the surface, they will come here and take control of you."

outlaunder, and wesa no caren about da Naboo."

Qui-Gon decided to put an end to this. Time was of the essence. He reached out with the Force, and nudged a thought into Boss Nass's mind. "Then speed us on our way."

Boss Nass blinked. "Wesa ganna speed yousaway."

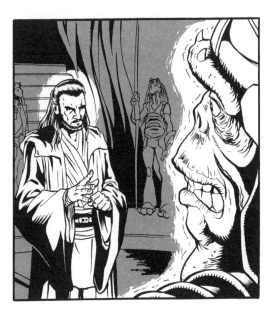

"Speed us on our way."

"We need a transport," the Jedi continued.

Boss Nass blinked again. "Wesa give yousa una bongo. Da speedest way tooda Naboo tis goen through da planet core. Now go."

Qui-Gon nodded. He had gotten what he wanted. "Thank you for your help. We leave in peace."

The Jedi turned to go, and Jar Jar

raised one hand. "Ahhh . . . any hep hair would be hot."

Qui-Gon turned back to Boss Nass. "What is to become of Jar Jar Binks?"

Boss Nass snorted. "Hisen to be pune-ished."

Qui-Gon considered. "We need a navigator to get us through the planet core. I have saved Jar Jar Binks's life.

He owes me what you call a 'life-debt.' Your gods demand that his life belongs to me now."

Casting one final, irritated look at Jar Jar, Boss Nass agreed. "Be gone with him!"

✴ A short time later, a small submarine pushed its way through the membranous dome and shot out into the murky water. Inside, Jar Jar and Obi-

Wan guided the craft while Qui-Gon sat behind them.

"Why were you banished, Jar Jar?" Obi-Wan asked.

Jar Jar frowned. "Tis a longo tale, buta small part wowdabe mesa . . . ooooh . . . aaa . . . clumsy."

"They banished you because you're clumsy?"

Jar Jar grinned in embarrassment.

"Mesa caus-ed mabee one or duey let-tal bitty ax-adents—"

Suddenly the submarine lurched to one side, its engines groaning. Qui-Gon glanced over to see a huge, glowing sea creature. The monster had hooked them with a long, adhesive tongue.

"Dassa opee sea killer!" Jar Jar screeched.

The monster had hooked them with a long, adhesive tongue.

"Full speed ahead," Qui-Gon recommended.

"I have the controls," Obi-Wan said, trying to stay calm. He adjusted the thrusters and sent full power to the engines. Instantly, the sub lurched forward. A larger monster had come up from behind and closed its enormous jaws around the opee sea killer, which vanished in a swirl of bubbles.

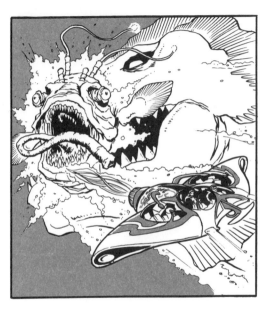

A larger monster had come up from behind and closed its enormous jaws around the opee sea killer.

"Always a bigger fish," Qui-Gon said.

Inside the sub, the lights suddenly extinguished themselves. In the dark cabin, sparks flew from damaged wires, and water leaked into the cabin from a crack in the hull.

"We're losing power," Obi-Wan said. He started to reconnect the damaged wires.

"We're losing power."

"Stay calm," Qui-Gon said evenly. "We're not in trouble yet."

Jar Jar slapped his head. "What yet? Monstairs out dare! Leank'n in here, all'n sink'n, and noo power! WHEN YOUS ATINK WESA IN TROUBLE?!"

Obi-Wan finished his work. "Power's back."

"WHEN YOUS ATINK WESA IN TROUBLE?!"

The lights came back on, just in time to illuminate the form of a clawed sea creature right in front of them. Obi-Wan slapped the controls and the submarine accelerated, racing through the monster's claws before they snapped shut.

✳ A river drifted lazily past the city of Theed, its waters gleaming with reflected sunlight. With a sudden rush,

*The submarine raced through the
monster's claws before they snapped shut.*

the smooth surface of the river was broken by the Gungan submarine.

The two Jedi and their Gungan guide emerged and crawled onto shore.

"Drop your weapons!"

A battle droid appeared out of the tree cover along the river bank. Casually, Qui-Gon reached for his lightsaber, but instead of dropping it he

ignited the weapon and slashed in one fluid movement. The laser sword passed through the droid's body and it clattered to the ground.

The two Jedi looked upriver to the city of Theed. In the center of the city, they could see the tall spires of the palace rise up into the sky. They started forward.

─✳─ Inside the palace, a strange

assembly gathered in the throne room. Queen Amidala stood at the center, wearing a regal gown and surrounded by four of her handmaidens. The Queen had painted her face in traditional Naboo makeup of bright white. The effect was startlingly beautiful. With them were her advisor, Governor Sio Bibble; her head of security, Captain Panaka; and four soldiers.

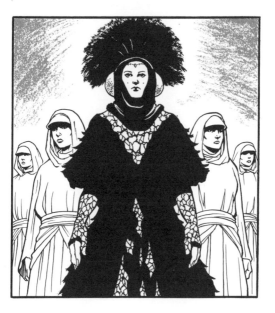

Queen Amidala stood at the center, wearing a regal gown.

All of them were held at blaster point by twenty battle droids as Nute Gunray and Rune Haako entered the room.

Governor Bibble demanded, "How will you explain this invasion to the Senate?"

Nute answered smugly, "The Naboo and the Trade Federation will

They were held at blaster point by twenty battle droids.

forge a treaty that will legitimize our occupation here. I've been assured it will be ratified by the Senate."

Queen Amidala said firmly, "I will not cooperate."

Nute chuckled. "Now, now, Your Highness. You are not going to like what we have in store for your people. In time, their suffering will persuade you to see our point of view." He

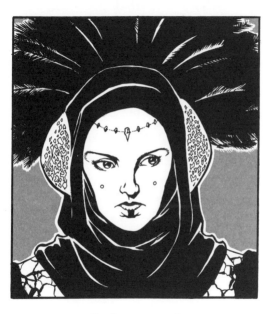

"I will not cooperate."

turned to one of the battle droids. "Commander!"

The commanding droid, OOM-9, stepped forward. "Sir?"

"Process them."

OOM-9 turned to his sergeant. "Take them to Camp Four!"

The sergeant and ten of the battle droids marched their prisoners out of

"Take them to Camp Four!"

———————————— ✳ ————

the throne room and down a long corridor.

Suddenly, the droids halted. Two robed humans dropped from above, along with a creature that registered in their sensors as a Gungan. The Jedi, lightsabers flashing faster than the machines could react, quickly dispatched the battle droids.

"We should leave the streets, Your

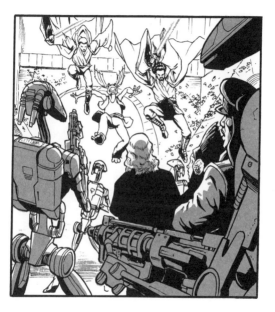

Two robed humans and a Gungan dropped from above.

Highness," Qui-Gon advised.

Jar Jar's jaw dropped. "Yousa guys bombad!"

Without speaking, the two Jedi led the freed prisoners to a secluded space between two buildings.

"Your Highness," Qui-Gon explained, "we are the ambassadors for the Supreme Chancellor."

"Your negotiations seem to have

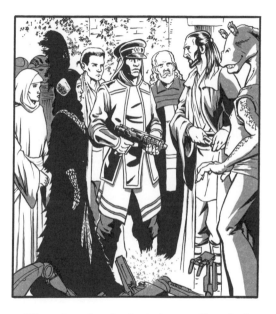

"We are the ambassadors for the Supreme Chancellor."

failed, Ambassador," Sio Bibble scoffed.

"The negotiations never took place. Your Highness, we must make contact with the Republic."

Captain Panaka stepped forward. "They've knocked out all our communications."

"Do you have transports?"

Panaka nodded. "In the main hangar."

✳ ——————————————

The group disappeared down an alleyway. Behind them, alarms began to sound.

✳ Qui-Gon remained calm, not simply to maintain his own connection with the Force, but to ease the fears of the people now under his care. They reached the main hangar bay. Cautiously, he leaned around a corner and peeked through a doorway, where

he saw several Naboo spacecraft guarded by fifty battle droids.

Captain Panaka risked a glance, too. "There are too many of them."

"That won't be a problem," the elder Jedi promised. He looked at the Queen. "Your Highness, under the circumstances, I suggest that you come to Coruscant with us."

The young Queen replied, "Thank

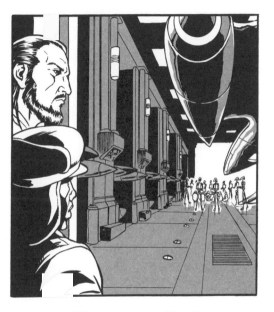

"There are too many of them."

you, Ambassador, but my place is here with my people."

"They'll kill you if you stay."

Panaka said, "They need her to sign a treaty to make this invasion legal. They can't afford to kill her."

Qui-Gon felt a faint disturbance in the Force. "There is something else behind all this, Your Highness. My feelings tell me they will destroy you."

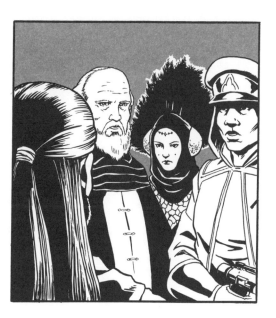

"They can't afford to kill her."

Bibble said, "Our only hope is for the Senate to side with us . . . Senator Palpatine will need your help."

Pondering this advice, the Queen turned to her handmaidens. "Either choice presents a great risk to us all."

One of the handmaidens, Padmé, nodded. "Be brave, Your Highness."

Qui-Gon said, "If you are to leave, it must be now."

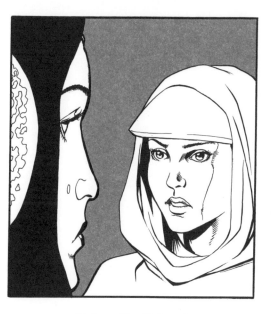

"Be brave, Your Highness."

The Queen straightened her back. "Then I will plead our case before the Senate."

✳ Leaving Governor Bibble and two of the handmaidens behind to help the people as best they could, the rest of the party entered the hangar bay and headed toward the Queen's star cruiser, a sleek chrome spacecraft. Nearby, twenty pilots and the palace

ground crew were held prisoner by six battle droids.

"We have to free those pilots," Panaka said.

Obi-Wan veered away from the others. "I'll deal with that."

As the young Jedi stalked toward the prisoners, Qui-Gon led the others boldly up to the star cruiser. Immediately, they were confronted by a

battle droid. "Where are you going?"

The elder Jedi explained casually, "I'm Ambassador for the Supreme Chancellor, and I'm taking these people to Coruscant."

"You're under arrest!" the droid barked. It drew its weapon, but far too slowly, and Qui-Gon's lightsaber cut it in two. More droids surged forward, and the Jedi moved to intercept them

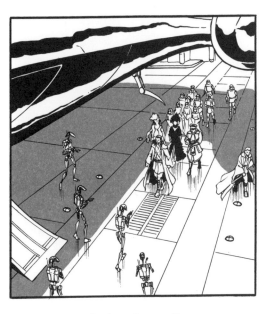

"You're under arrest!"

as the others rushed aboard the ship. Qui-Gon's movements were graceful, fluid, and lethal. He effortlessly blocked blaster bolts and sent them hurtling back toward their points of origin, while simultaneously slashing through any droids that tried to rush him. Because he was one with the Force, each sweep of his saber lined up precisely with the blaster

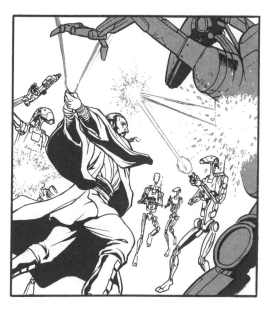

Qui-Gon's movements were graceful, fluid, and lethal.

bolts that streaked toward him.

In moments, the droids lay in shattered heaps at his feet.

Obi-Wan appeared, leading the freed pilots. As more battle droids entered the hangar, the pilot closed the hatch and ignited the engines, rocketing away from the palace.

✳ The Naboo cruiser streaked up into the stratosphere with pilot Ric

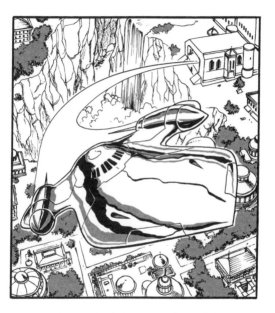

The pilot closed the hatch and ignited the engines, rocketing away from the palace.

Olié at the controls. Immediately, alarms filled the cruiser's cockpit as they entered space—and a fleet of battleships. Ric Olié's scanners were bright with multicolored blips. The Trade Federation starfighters, approaching at high speed, opened fire.

Laser fire pounded against the cruiser, damaging the defensive shield generator.

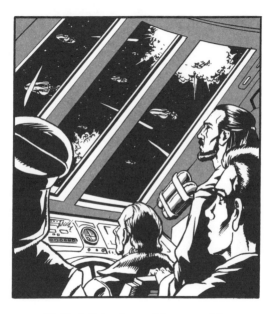

The Trade Federation starfighters opened fire.

In a small hold in the rear of the ship, five dormant astromech droids suddenly came on line, triggered by a damage alert screeching through a speaker. One by one the droids scurried to an airlock and were instantly ejected onto the hull of the ship.

The droids raced along the hull of the Queen's ship. Before they could reach their goals, three of the astro-

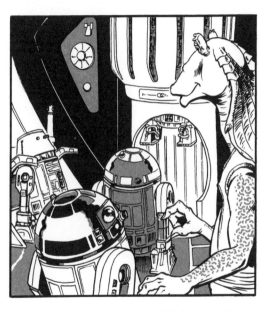

Five dormant astromech droids suddenly came on line.

mech droids were blasted by enemy fire. One more droid was blown apart, but the last droid, a blue and white unit, reached its designated point on the ship's hull and began to make repairs. It extended an appendage and connected two wires. Instantly, the Naboo ship's damaged shields were completely repaired. The small droid emitted a whistle of satisfaction and

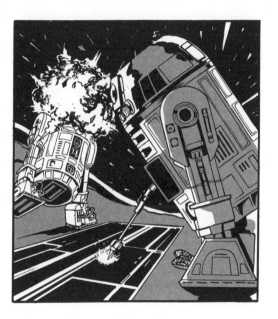

One more droid was blown apart.

made his way back to the airlock.

✳ Inside the ship, the Jedi and their charges watched the Trade Federation fighters fall behind. They had escaped thanks to the help of the surviving droid. Captain Panaka checked the droid's code: R2-D2. The captain smiled. The name had a nice ring to it.

But Ric Olié checked his gauges. "There's not enough power to get us to

Coruscant. The hyperdrive is leaking."

Qui-Gon realized the ship would never reach Coruscant. "We'll have to land somewhere to repair the ship."

Obi-Wan scanned the starcharts and found a suitable planet. "Here, Master. It's small, out of the way, and poor. The Trade Federation has no presence there. It's called Tatooine."

✳ In the main conference room of

the Trade Federation battleship, Nute Gunray and Rune Haako cowered before the holo-image of Darth Sidious.

"Has Queen Amidala signed the treaty?" the Sith Lord demanded.

Nute had been dreading the question. "She has disappeared, my lord. One Naboo cruiser got past the blockade."

Darth Sidious's anger seemed to

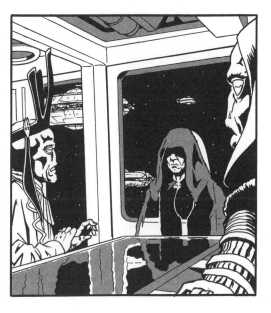

"Has Queen Amidala signed the treaty?"

reach them through the holo-transmission. "Viceroy, find her! I want that treaty signed!"

"My lord, it's impossible to locate the ship. It's out of our range!"

"Not for a Sith," Sidious said.

A second Sith Lord appeared behind him. "Viceroy, this is my apprentice, Lord Maul. He will find your lost ship."

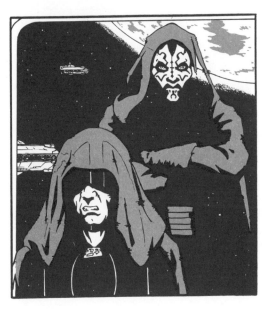

"Viceroy, this is my apprentice, Lord Maul."

✳ The Queen's star cruiser settled into the dust of Tatooine a few kilometers outside a desert spaceport called Mos Espa.

Qui-Gon decided to take Jar Jar and the droid along with him to get repair materials. The Gungan's company would make a single human less obvious on a port planet such as this, and the droid could carry the specs of

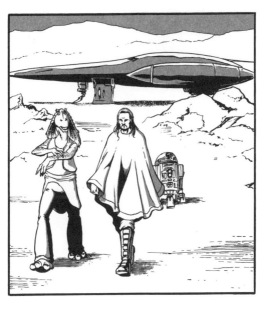

Qui-Gon decided to take
Jar Jar and the droid along with him.

the equipment they needed. At the last minute, he was forced to take one of the Queen's handmaidens as well.

"Her Highness wishes for her to observe," Captain Panaka said, pointing to Padmé.

"This spaceport is not going to be pleasant," the Jedi warned.

"I've been trained in defense," the young handmaiden declared. "I can

take care of myself."

Assenting, the Jedi led his small troupe across a span of sand and into a city of squat houses and buildings. A menagerie of alien species scurried through its streets, sticking to the shade to protect themselves from the suns . . . and from prying eyes.

The Jedi headed for a plaza containing several junk shops and entered

the nearest one. A short blue alien, named Watto, fluttered toward them on fast-beating wings and confronted them, speaking in a guttural dialect of Huttese. *"Hi chuba da nago?"*

Qui-Gon replied, "I need parts for a J-type 327 Nubian."

In Basic, the junk dealer said, "Ah yes, Nubian. We have lots of that."

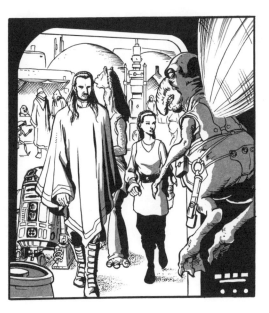

*A short blue alien fluttered
toward them on fast-beating wings.*

Watto scratched his scruffy chin, then called out to someone in the back. A small human boy of about nine appeared. "Watch the store. I've got some selling to do here," he said in Huttese.

Qui-Gon and the droid R2-D2 followed Watto out into the junk yard, leaving Padmé and Jar Jar with the boy.

The boy walked up to Padmé, his eyes never leaving her face. He had

A small human boy of about nine appeared.

never seen anyone so beautiful in his life. "Are you an angel?"

"What?"

"An angel," the boy said. "I've heard the deep-space pilots talk about them." They live on the moons of Iego, I think."

Padmé was taken aback. "You're a funny little boy. How do you know so much?"

"Are you an angel?"

"I listen to all the traders and star pilots. I'm a pilot, you know, and someday I'm going to fly away from this place."

"You're a pilot?" the handmaiden asked.

The boy puffed out his chest. "All my life."

Padmé laughed. "How long have you been here?"

"You're a pilot?" the handmaiden asked.

"Since I was very little, three, I think. My mom and I were sold to Gardulla the Hutt, but she lost us betting on the Podraces."

Padmé was shocked. "You're . . . a slave?"

"I am a person!" the boy declared. "My name is Anakin."

✳︎ Out in the junkyard, Watto fluttered over to the parts Qui-Gon

"My name is Anakin."

---— ✳ —

needed. "How's thee going to pay for all this?"

The Jedi said, "I have 20,000 Republic dataries."

Watto sputtered, "Republic credits! Republic credits are no good out here. I need something more real."

Qui-Gon gathered himself in the Force. "Credits will do fine."

"How's thee going to pay for all this?"

Watto shook his head. "No, they won't."

Qui-Gon motioned with his hand and repeated, "Credits will do fine."

Watto laughed. "What you think you're some kinda Jedi, waving your hand around like that? I'm a Toydarian. Mind tricks don'ta work on me. Only money. No money, no parts, no deal."

—✳— Defeated, the Jedi returned to the shop to gather up the rest of his party. Out on the street, Qui-Gon contacted the ship over his comlink and asked Obi-Wan to search the ship for anything valuable. But the younger Jedi came up empty-handed. Aside from Queen Amidala's rather expansive wardrobe, the ship was empty.

Qui-Gon sighed. "Very well.

Another solution will present itself. I'll check back."

As they started down the street, they were stopped by Anakin, who had just been released from his duties. He pointed to the rapidly darkening skies. "There's a storm coming in. Do you have shelter?"

"Our ship is on the outskirts," Qui-Gon said.

"There's a storm coming in. Do you have shelter?"

The little boy shook his head. "You'll never make it in time. Sandstorms are very, very dangerous. Come with me."

Anakin led them to the poorest section of the spaceport, with tiny mud hovels built one on another. The boy led them through a small door and into a modest flat, where he was

*"You'll never make it in time. Sandstorms
are very, very dangerous. Come with me."*

greeted by a woman. Labor seemed to have doubled her years, but she managed a smile for the strangers, even as she was startled to find so many people enter her tiny home.

"This is my mom, Shmi. Mom, this is Padmé," Anakin said. "And . . . gee, I don't know any of your names."

Qui-Gon introduced himself and Jar Jar, and, prompted by a com-

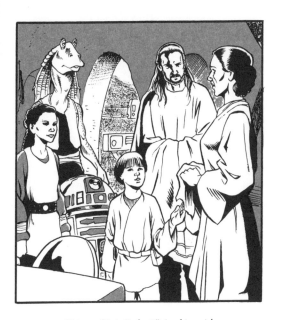

"Mom, this is Padmé," Anakin said.
"And … gee, I don't know any of your names."

plaining bleep, he added, "This is Artoo-Detoo."

"I'm building a droid," Anakin said to Padmé. "Let me show you Threepio!" Anakin led Padmé into his room, followed by the beeping Artoo. A protocol droid consisting only of wires and a metal frame lay on a workbench. "Isn't he great? He's not finished yet," Anakin explained. Anakin reached

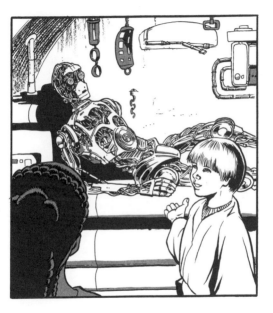

"Isn't he great? He's not finished yet."

behind the droid and pressed a button.

"How do you do, I am See-Threepio, Human Cyborg Relations," the droid said.

"He's perfect," Padmé said.

✳ One vast metropolis covered the entire planet of Coruscant. On a single balcony overlooking the city lights, which spread to the horizon, two dark figures whispered to one another.

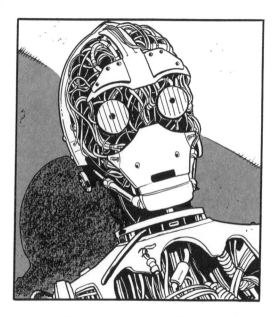

*"How do you do, I am See-Threepio,
Human Cyborg Relations."*

Darth Maul had managed to track the course of the damaged Naboo cruiser, and he had plotted their likeliest hiding place. "Tatooine is sparsely populated. If the trace is correct, I will find them quickly, Master."

Darth Sidious nodded. "Move against the Jedi first. You will then have no difficulty in taking the Queen back to Naboo."

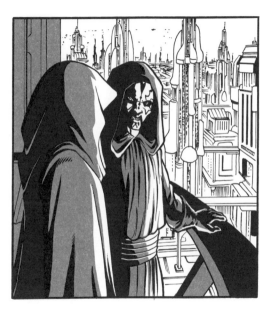

"*Tatooine is sparsely populated. If the trace is correct, I will find them quickly, Master.*"

The younger Sith Lord grinned evilly. "At last we will reveal ourselves to the Jedi. At last we will have revenge."

Sidious growled, "You have been well trained, my young apprentice. They will be no match for you."

※ Qui-Gon tried to ease the shock of their appearance by offering Shmi food to add to the evening meal.

While the food was being served, Anakin stole glances at Padmé. Finally, he said, "Have you ever seen a Podrace?"

Qui-Gon answered, "They have Podracing on Malastare. Very fast, very dangerous."

Anakin puffed up, "I'm the only human who can do it."

Qui-Gon said, "You must have

Jedi reflexes if you race Pods."

Anakin said, "You're a Jedi Knight, aren't you? I saw your laser sword. Only Jedi carry that kind of weapon."

Qui-Gon thought for a moment. "I can see there's no fooling you, Anakin. We're on our way to Coruscant, the central system in the Republic, on a very important mission. It must be kept secret."

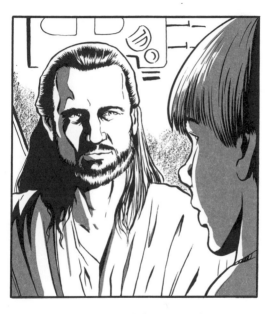

"I can see there's no fooling you, Anakin."

"Coruscant!" the boy said. "How'd you end up here in the Outer Rim?"

"Our ship was damaged, and we're stranded here until we can repair it."

Anakin's eyes lit up. "I can help! I can fix anything!"

The Jedi smiled. "I believe you can, but our first job is to acquire the parts we need."

Padmé wrinkled her brow. "These

junk dealers must have a weakness of some kind."

"Gambling," Shmi replied. "Everything here revolves around betting on those awful races."

Anakin nearly jumped out of his seat. "I've built a racer! It's the fastest ever. And there's a big race tomorrow, on Boonta Eve. You could enter my Pod."

His mother touched his arm. "Anakin, Watto won't let you—"

"Watto doesn't know I've built it." He pleaded with the Jedi. "You could make him think it was yours, and you could get him to let me pilot it for you. The prize money would more than pay for the parts you need."

Qui-Gon did not want to put an innocent life in danger, but he could

feel the Force moving strongly in the boy, and he knew their meeting was no accident. He looked at Anakin's mother.

Shmi felt distraught. But she could see the eagerness in her son's eyes, and she had endured the hardships of Tatooine long enough to know that if they did not help the strangers, no one would. She nodded her consent.

✦ It took some convincing, but Watto agreed to the deal Qui-Gon presented. The Jedi offered the Naboo cruiser as collateral and entered "his" Pod in the race. In return, Watto agreed to lend Anakin as pilot, and to front the money for the entry fee. If Anakin won, the junk dealer would keep the winnings, but he would give the Jedi all the parts needed to repair

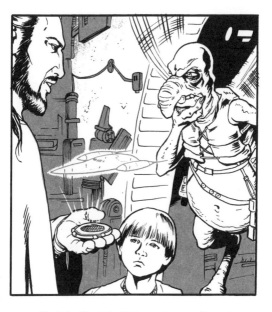

The Jedi offered the Naboo cruiser as collateral.

the ship. If Anakin lost, Watto got the Queen's starship itself, and the refugees would become castaways on Tatooine.

Back at Anakin and Shmi's house, Qui-Gon took Shmi outside and they spoke as the daylight faded into night. "You should be proud of your son. He gives without any thought of reward."

She nodded. "He knows nothing

"You should be proud of your son. He gives without any thought of reward."

of greed. He has—"

"He has special powers," the Jedi finished for her. "He can see things before they happen. That's why he appears to have such quick reflexes. It is a Jedi trait."

Shmi said, "He was special from the very beginning. Can you help him? He deserves better than a slave's life."

The old Jedi frowned. "I'm afraid

"Can you help him? He deserves better than a slave's life."

not. Had he been born in the Republic, we would have identified him early, and he would have become a Jedi, no doubt. But it's too late for him now. He's too old."

✳ Anakin's young friends gathered in his backyard to watch Anakin ready his Pod for the Boonta race.

"Come on, let's go play ball. Keep it up, Annie, and you're gonna be bug

Anakin's young friends gathered in his backyard to watch Anakin ready his Pod for the Boonta race.

squash!" said Seek, a young boy about Anakin's age.

Kitster, Anakin's best friend, added, "You don't even know if this thing will run."

Qui-Gon approached the group and gave Anakin a small power cell. "It's time we found out. Use this power charge."

"Yes, sir!" Anakin installed the

"You don't even know if this thing will run."

power cell and the engines roared. "It's working! It's working!"

-*- Sitting on a balcony rail near the hovel, Qui-Gon tended to a small cut on Anakin's arm. He wiped off a patch of blood and placed it on a chip, which he carefully put in a pocket of his robe.

"What are you doing?" Anakin asked.

⁎ ─────────────────────

"Checking your blood for infections," the Jedi replied.

⁎ Later that evening Qui-Gon took the blood-stained chip and inserted it into a communications device. He called Obi-Wan. "Make an analysis of this blood sample I'm sending you. I need a midi-chlorian count."

Obi-Wan checked the sample. "The reading's off the chart. Even

Master Yoda doesn't have a midi-chlorian count this high! What does it mean?"

Qui-Gon pondered for a moment. "I'm not sure."

✳ Even as they spoke, out in the dry expanse of desert, a dark ship screamed down to the surface. Darth Maul stepped out, seemingly drawing the night down with him. With a pair

*"Even Master Yoda doesn't have
a midi-chlorian count this high!"*

of electrobinoculars, he scanned the desert, identifying three separate settlements. One click of a remote control sent six small probe droids hurtling through the air and toward the distant lights.

✳ Race-day dawned hot and dry, and the morning hours passed quickly as Anakin, working in the racers' hangar bay, prepared his Pod for the

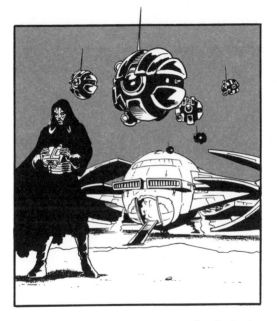

One click of a remote control sent six small probe droids hurtling through the air and toward the distant lights.

race. Many of the racers of other species tittered and chortled at him. The worst of these was a famous racer named Sebulba. He was a Dug, and Anakin had seen him race before. He had multiple limbs, and multiple moods—all of them bad. And he had never lost a race.

Qui-Gon approached Watto in the Pod hangar and added a final

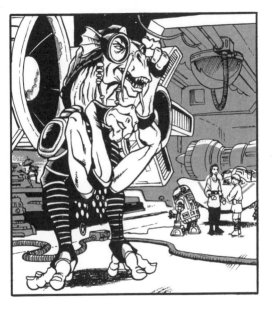

Sebulba had multiple limbs, and multiple moods—all of them bad. And he had never lost a race.

wrinkle to their bet. He bet the Pod Anakin had built against the boy and his mother's freedom.

Watto choked. "No Pod's worth two slaves. One or nothing."

"The boy, then," Qui-Gon said.

Watto finally agreed. Saying nothing of this additional wager, Qui-Gon rejoined the others.

✳ Start time approached and the

———✳———

racers lined up at the starting gate. Their small control Pods sat behind the massive engines of their vehicles, connected only by thin tethers. Anakin crouched in his Pod, making last-minute adjustments and trying to ignore the glares of Sebulba, who had been lined up next to him.

Qui-Gon walked up to the Pod. "Are you all set, Anakin?"

The boy nodded. He was ready.

"Remember," the Jedi said, "concentrate on the moment. Feel. Don't think. Use your instincts." He smiled. "May the Force be with you."

 Anakin held onto those words as he ignited his engines. Instantly, a deafening roar filled his ears, which only grew louder as the other racers started

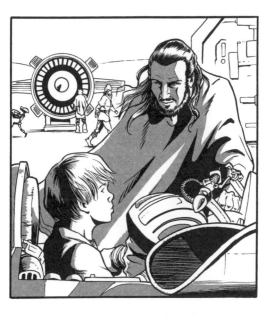

"May the Force be with you."

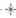

their engines as well. On a bridge over the track, a great green light flashed, and the Podracers shot forward.

But not Anakin's. His engines flooded and coughed, then died.

The other racers sped ahead as the boy struggled to restart his Pod. Finally, the engines cleared, and his vessel shot forward with a ground-shaking roar.

It took him precious moments to

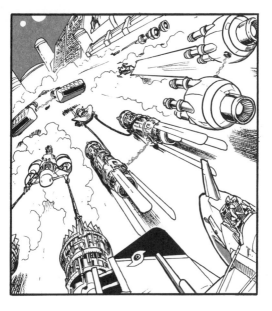

The other racers sped ahead.

catch the stragglers, but his Pod was far faster and he passed them quickly. Sebulba and the leaders, he knew, would be harder to catch.

Unless he took some serious risks.

Heading into a sharp turn, Anakin knew he should slow down. Instead, he gunned his engines. The crowd cheered.

Concentrate on the moment. Feel.

—✳————————————————

Don't think. Use your instincts.

Without even realizing it, Anakin followed Qui-Gon's advice. He did not think about the end of the race. He did not even think about Sebulba, far out in the lead. He simply thought about the racer in front of him, and then the next, and the next, until he had slipped past each of them.

By the start of the second lap,

Anakin had caught the leaders. The crowd roared its approval.

Ahead he saw Sebulba's orange Podracer, with another Pod gaining fast. He saw Sebulba reach for something, and knew instinctively what was coming. Sebulba let go of a small piece of metal, which hurtled backward, and smashed into the closest pursuer. The hapless Podracer veered

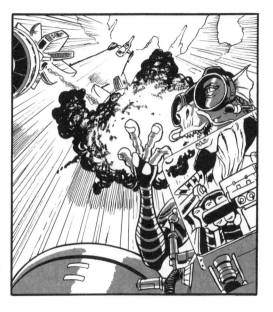

*Sebulba let go of a small piece of
metal, which hurtled backward.*

away, crashing into Anakin before slamming into the ground.

Another racer moved up to challenge Sebulba. The devious Dug flipped a switch, opening a vent in the side of his engines and spewing exhaust into the hull of the challenger. The super-heated exhaust cut through his opponent's engines and the racer crashed.

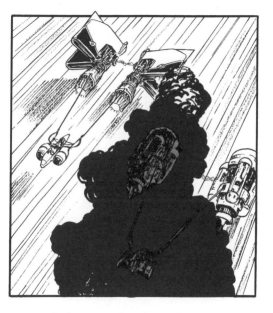

*The devious Dug flipped a switch, spewing
exhaust into the hull of the challenger.*

As they streaked past the viewing platform for the final time, Anakin and Sebulba were running almost neck and neck.

Anakin bided his time, searching for the right moment to pass. Finally, he faked toward the inside, then cut outside as Sebulba tried to block him and caught up. The two Pods strained nose to nose.

Anakin and Sebulba were running almost neck and neck.

From his seat, Sebulba cursed something inaudible and jerked hard on his steering arm. His Pod veered sideways, smashing into Anakin. The boy struggled to maintain control. Again Sebulba smashed into him. This time, the steering rods on the two Podracers became hooked together. Sebulba only laughed.

As they headed down the final

The steering rods on the two Podracers became hooked together.

stretch, Anakin fought to unlock the steering rods by pulling away from the other Pod. Something groaned, and the boy heard the shriek of tearing metal. His steering arm snapped off its base, and his Pod began to wobble.

The sudden torque shook Sebulba free, but it threw his Pod out of control. The Podracer smashed into an ancient statue marking the final length of the

The Podracer smashed into an ancient statue.

course. One of the engines exploded, then the other, and the pilot Pod skipped through twin walls of flame. Sebulba came out the other side, his face blackened and his clothes smoldering. He stared down the track. Anakin was already out of sight.

The crowd roared as Anakin's Pod crossed the finish line. Spectators surged out of their seats and down

The crowd roared as Anakin's Pod crossed the finish line.

onto the courseway, and Qui-Gon pulled the boy out of his Podracer and lifted him onto his shoulders.

✳ Qui-Gon returned to Anakin's quarters. He had sold the winning Pod, and he delivered money to Shmi. Then he explained his second bet with Watto.

"Anakin's been freed."

Shmi was stunned. "Now you can

make your dreams come true, Annie." She looked at Qui-Gon. "Is he to become a Jedi?"

The Jedi looked at Anakin. "Our meeting was not by coincidence. Nothing happens by accident."

"Can I go, Mom?" Anakin asked.

Qui-Gon replied, "Anakin, this path has been placed before you. This choice is yours alone."

"I want to go," the boy declared.

"Then pack your things. We haven't much time," Qui-Gon said.

Anakin went into his room to say good-bye to C-3PO. "Well, Threepio, I'm free. And I'm going away in a starship. I'm sorry I wasn't able to finish you. I'll make sure Mom doesn't sell you or anything."

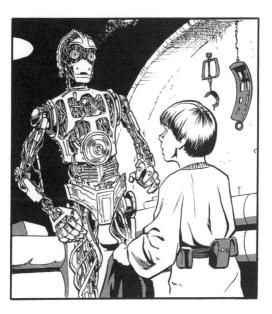

"Well, Threepio, I'm free."

Threepio stared at Anakin as the boy rushed from the room. "Sell me?!?"

✳ In the excitement of the moment, Anakin had forgotten what was nearest and dearest to his heart. But as Qui-Gon waited, Anakin suddenly stopped and looked back at his mother. He was leaving her. Sudden doubt filled him.

"I can't do it, Mom. I just can't."

Anakin suddenly stopped and looked back at his mother.

Shmi gave her son a hug. Watching him leave was so hard, but she knew it was for the best.

"Will I ever see you again?" he asked.

"What does your heart tell you?" she asked.

"I hope so," Anakin said at last. "Yes, I guess."

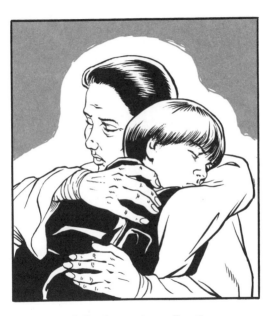

"What does your heart tell you?"

"Then we will see each other again."

"I will come back and free you, Mom," Anakin promised.

Shmi released her son from their hug and turned him around to face the waiting Jedi. "Now be brave, and don't look back."

Gathering his courage, Anakin left his mother and joined Qui-Gon,

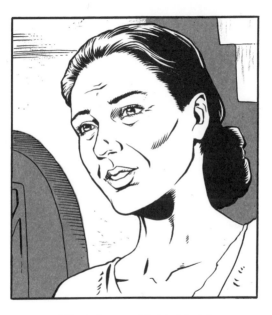

"Now be brave, and don't look back."

taking his first steps into a new life.

In a few moments they had left the city and were sprinting across the sand toward the waiting cruiser.

"Qui-Gon," Anakin asked, "is that your ship?"

Qui-Gon turned to respond, and saw a dark figure hurtling toward them on a speeder bike. "Anakin, drop!"

The boy obeyed, and the speeder

"Anakin, drop!"

bike swept over his head. With no hesitation, Darth Maul leaped from the back of the speeder and swung a death blow with his laser sword. Qui-Gon blocked it.

Barely.

Maul's onslaught was relentless. Qui-Gon battled back, matching the Sith Lord's assault with the focused calm of a Jedi Knight. They traded

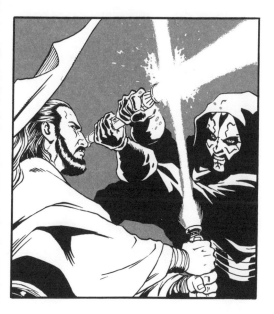

*Darth Maul leaped from the back of the speeder
and swung a death blow with his laser sword.*

powerful blows that sent energy sparks leaping into the air.

In the midst of the battle, Qui-Gon cried, "Annie, get to the ship! Take off!"

Anakin obeyed. He ran to the nearby ship and scrambled up the ramp, shouting, "Qui-Gon's in trouble. He says to take off . . . now!"

The pilot Ric Olié dove for the

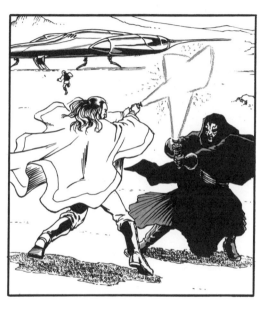

"Annie, get to the ship!"

controls as Obi-Wan scanned the desert. "Over there! Fly low!"

The Naboo cruiser rose, churning up dust as it moved, and turned toward the Jedi and the Sith.

Qui-Gon leaped over a saber slash, somersaulted in mid-air, and landed on his feet. The Sith Lord whirled around to face him again. The Jedi lunged forward, then suddenly the two

—✳——————————————

warriors were enveloped by the dust cloud. Darth Maul looked around, searching for his prey. Finally, he looked up—and saw Qui-Gon standing on the entry ramp ten meters overhead.

Darth Maul leaped. He reached the entry ramp, but just barely. His heels hung over the edge as he tried to catch his balance. Qui-Gon stepped

forward, delivering a powerful blow with his sword. The Sith Lord blocked it, but the force of the blow drove him off the platform and he fell back toward the planet. In the same moment, Qui-Gon dove into the ship, and the Naboo cruiser ignited its sublight engines and vanished into the blue Tatooine sky.

─✳ Hours later, the Naboo cruiser

The Naboo cruiser vanished into the blue Tatooine sky.

punched its way out of hyperspace. The ship descended toward the night-side of a planet dotted with sparkling lights from hemisphere to hemisphere, like a field of stars within the larger field of stars. It was the planet city of Coruscant, the capital of the Republic.

Entering the atmosphere, the cruiser swept toward the Senate

The ship descended toward the nightside of a planet dotted with sparkling lights.

landing platform and docked. As the Jedi and the Naboo entourage debarked, they found several important figures waiting for them, not least of which was Supreme Chancellor Valorum himself. Beside him stood a thin, kindly looking man: the Senator from Naboo, whose name was Palpatine.

The two Jedi excused themselves to visit the Jedi Council. Queen

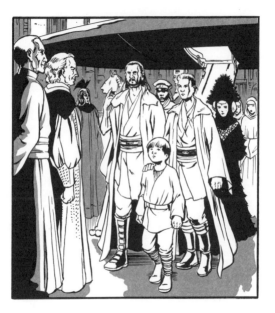

As the Jedi and the Naboo entourage debarked, they found several important figures waiting for them.

Amidala, her handmaidens, and the others were accompanied by Palpatine to his private quarters where Palpatine gave Amidala his report.

"The Republic is not what it once was. The Senate is full of greedy, squabbling delegates. There is no interest in the common good. There is little chance the Senate will act on the invasion."

Amidala replied, "Chancellor Valorum seems to think there is hope."

Palpatine pursed his lips. "If I may say so, Your Majesty, the Chancellor has little real power. He is mired by baseless accusations of corruption."

"What options have we?"

Palpatine smiled. He had a plan, and in the next few moments, he shared it with the young Queen.

⋇ Meanwhile, Qui-Gon and his young apprentice stood before the twelve members of the Jedi Council as Qui-Gon told of his dangerous encounter.

"My only conclusion," the Jedi said, "can be that it was a Sith Lord."

"A Sith Lord!" cried Mace Windu, a senior Jedi.

"My only conclusion," the Jedi said,
"can be that it was a Sith Lord."

"Impossible," said another, Ki-Adi-Mundi. "The Sith have been extinct for a millennium."

A third Jedi, a small, clear-eyed creature named Yoda, said, "The very Republic is threatened, if involved the Sith are."

Mace Windu said, "This attack was with purpose, that is clear. The Queen is his target."

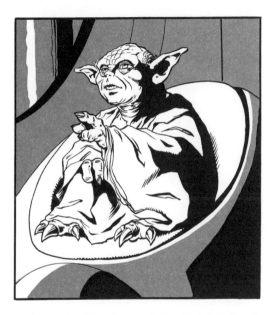

"The very Republic is threatened, if involved the Sith are."

Yoda looked at Qui-Gon. "With this Naboo Queen you must stay. Protect her."

Mace Windu concluded, "We will use all our resources here to unravel this mystery and discover the identity of your attacker. May the Force be with you."

The statement was meant as a dismissal, but Qui-Gon did not budge.

———✳———

"Master Qui-Gon, more to say have you?" Yoda asked.

Qui-Gon told them about the boy he had encountered. "His cells have the highest concentration of midichlorians I have seen in a life form."

Mace Windu leaned forward. "You're referring to the prophesy of the one who will bring balance to the Force. You believe it's this boy?"

"I request the boy be tested."

"Bring him before us, then," Mace Windu declared.

—※ The rotunda of the Galactic Senate was a galaxy within a galaxy, with thousands of representatives standing in their hovering senatorial boxes as Chancellor Valorum ran through the daily procedures of the government.

In the Naboo box, Amidala stood

"I request the boy be tested."

impatiently beside Palpatine. Finally, their turn on the agenda came up. Their box rushed forward, flying into the main chamber, signaling that they held the floor.

Gathering herself, Amidala announced, "The Naboo system has been invaded by the droid armies of the Trade Federation!"

The Trade Federation delegate was

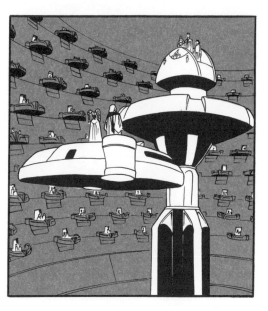

*"The Naboo system has been invaded by
the droid armies of the Trade Federation!"*

ready for her announcement. As all eyes turned to him, he replied, "We recommend a commission be sent to Naboo to ascertain the truth of this alleged invasion."

Valorum started to overrule him, when one of his aides grabbed his sleeve and whispered in his ear. The Chancellor's face fell. Turning back to the delegates, he sighed, "The point is

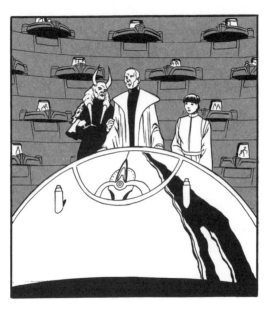

Valorum started to overrule him, when one of his aides grabbed his sleeve and whispered in his ear.

conceded. Queen Amidala, will you defer your motion to allow a commission to explore your accusations?"

"I will not defer!" the young Queen declared. "I was not elected to watch my people suffer and die while you discuss this invasion in a committee!"

She glanced at Palpatine, and the wizened Senator nodded. This was exactly the sort of politics he had

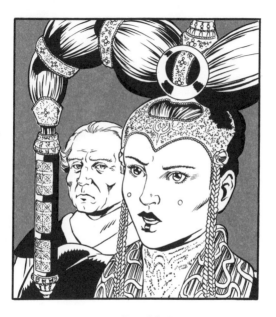

"I will not defer!"

warned her about. And he had given her the solution. Straightening up, she called out, "If this body is not capable of action, I suggest new leadership is needed. I move for a vote of no confidence in Chancellor Valorum's leadership!"

"Vote now!" the senators chanted.

The Chancellor paled and slowly sat down.

⁎ ───────────────────────────────

Other voices continued the cry. In a single moment, the Supreme Chancellor was snared in the same laws that had upheld him.

⁎ In Palpatine's quarters, Queen Amidala stole a private moment alone. Two of her handmaidens waited near the door, and Jar Jar Binks stood nearby watching her stare out the window. He didn't know much about

the Naboo, or about humans, for that matter. But he could see this young creature was sad.

"Yousa tinken yousa people ganna die?"

Amidala said simply, "I don't know."

"Gungans get pasted too, eh?"

"I hope not."

Jar Jar shook his head. "Gungans

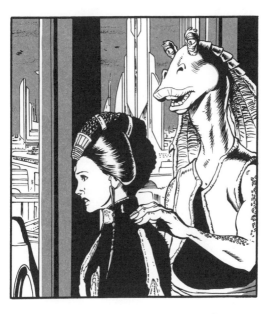

He could see this young creature was sad.

no die'n without a fight . . . wesa warriors. Wesa gotta grande army."

At that moment Captain Panaka rushed in with Palpatine beside him. "Your Highness," Panaka said, "Senator Palpatine has been nominated to succeed Valorum as Supreme Chancellor."

Palpatine bowed his head modestly. "A surprise, to be sure, but a welcome

"Senator Palpatine has been nominated to succeed Valorum as Supreme Chancellor."

one. Your Majesty, if I am elected, I promise I will bring democracy back to the Republic."

Amidala turned to face them. "I fear by the time you are elected there will be nothing left of our people. Senator, this is your arena. I feel I must return to mine."

Palpatine was shocked. "Please, Your Majesty, stay here, where it's safe."

"I fear by the time you are elected there will be nothing left of our people."

The Queen shook her head. "It is clear to me now that the Republic no longer functions. I pray you will bring sanity back to the Senate." She turned and left the room. Behind her, Palpatine allowed himself a small, self-satisfied smile.

⚹ "He is to be trained, then?" Qui-Gon asked.

He had been summoned before

Palpatine allowed himself a small, self-satisfied smile.

the Jedi Council. They had tested the boy and found that the Force was indeed strong in him.

"No, he will not be trained," said Mace Windu. "He is too old."

Yoda added, "Clouded, this boy's future is."

Qui-Gon stiffened. "I will train him, then. I take Anakin as my Padawan learner."

"No, he will not be trained," said
Mace Windu. "He is too old."

"An apprentice you have, Qui-Gon," Yoda said, indicating Obi-Wan. "Impossible to take a second."

Mace Windu interjected, "Now is not the time for this. The Senate is voting for a new Supreme Chancellor. Queen Amidala is returning home, which will put pressure on the Trade Federation, and could widen the confrontation."

—✳—

"And draw out her attacker," Ki-Adi-Mundi added.

"Events are moving fast," Yoda said. "Too fast."

Mace Windu said seriously, "Go with the Queen to Naboo and discover the identity of this dark warrior."

—✳— The two Jedi and Anakin awaited the Queen and her entourage on the Senate landing platform.

By now, Anakin had heard the Council's decision. He had also heard that Qui-Gon insisted on watching over him even though he would not become a Jedi. "Qui-Gon, sir, I don't want to be a problem."

Qui-Gon sighed. "You won't be, Annie. I'm not allowed to train you, so I want you to watch me and be mindful. Always remember, your

focus determines your reality."

"I've been wondering. What are midi-chlorians?"

Qui-Gon explained as simply as he could. "Midi-chlorians are a microscopic life form that resides within all living cells and communicates with the Force. They are continually speaking to us, telling us the will of the Force."

Anakin wanted to ask more

questions, but the Queen arrived with her handmaidens and the others from Naboo. Together, they boarded their cruiser, and with little fanfare, launched out into space, and back toward the dangers of Naboo.

Jar Jar threw up his arms. "Wesa goin' home!"

✳ A single hologram crackled to life in the palace of Theed. Nute Gunray

The Queen arrived with her handmaidens and the others from Naboo. Together, they boarded their cruiser.

and Rune Haako waited for Darth Sidious to speak.

"Is the planet secure?"

"Yes, my lord," Nute said. "We have taken over the last pockets of primitive life forms. We are in complete control of the planet."

"Good. I will see to it that in the Senate, things stay as they are. I am sending my apprentice Darth Maul to

"We are in complete control of the planet."

join you. He will deal with the Jedi."

✳ The journey to Naboo was short, but the time dragged for those aboard the cruiser. Anakin occupied himself in the cockpit, learning the controls from Ric Olié. Captain Panaka spent his time trying to dissuade the Queen from fulfilling her foolhardy proclamation.

"As soon as we land, the Trade

✳ ─────────────────────────────

Federation will arrest you, and force
you to sign the treaty."

"I agree," Qui-Gon said. "I'm not
sure what you wish to accomplish by
this."

"I'm going to take back what's
ours," Amidala said firmly.

The Jedi shrugged. "I can only pro-
tect you. I cannot fight a war for you."

Amidala turned her gaze away from

the elder Jedi. "Jar Jar Binks!" The Gungan nearly fell out of his seat. Amidala smiled at him. "I need your help."

✳ The Queen's ship dropped out of hyperspace over the lush green planet of Naboo. Only one Trade Federation battleship could be seen.

"The blockade's gone," Captain Panaka noted.

"The war's over," Obi-Wan replied.

The Queen's ship dropped out of hyper-space over the lush green planet of Naboo.

"That battleship is the droid control ship. We haven't much time."

The ship landed in the Gungan swamp. As Queen Amidala explained her plan to the Jedi, Jar Jar Binks swam through the waters of Naboo. It felt good to wash away the sand of Tatooine and the grime of Coruscant in the waters of home. Eagerly, he

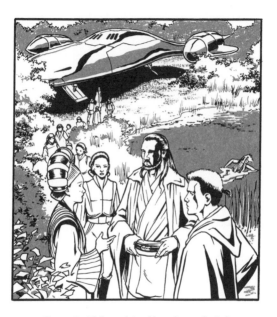

Queen Amidala explained her plan to the Jedi.

reached Otoh Gunga and slid through the protective dome.

His footsteps echoed loudly. The city was empty.

Glancing around, he saw blast holes in many of the nearby buildings. He shuddered. The Trade Federation had found Otoh Gunga.

✴ "Dare-sa nobody dare," he said when he returned to the others.

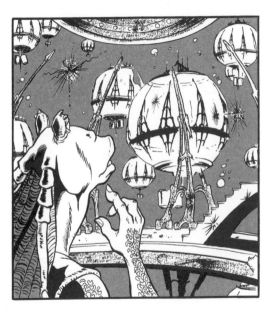

The Trade Federation had found Otoh Gunga.

———————————— ✳

"Some kinda fightin, mesa tink."

"Do you think they have been taken to camps?" Captain Panaka asked.

"Mesa no tink so," Jar Jar replied. "Gungan hiden. When in trouble, go to sacred place."

"Do you know where they are?" Qui-Gon asked.

"Mesa show you. Come on."

✳ Jar Jar Binks led the others through the swamp. The terrain appeared to be the same, kilometer after kilometer, but the Gungan guided them as if there were a clearly marked path.

The other Gungans appeared without warning. Six Gungan soldiers riding kaadu charged out of the underbrush, surrounding the newcomers.

From the saddle of his kaadu, Captain Tarpals recognized at least one of the new arrivals.

The Gungan soldiers led the newcomers to the ruins of a grand temple with massive stone heads scattered about. Boss Nass and his council stood atop one of the sculptures.

"Jar Jar Binks! Who's da uss'en others?"

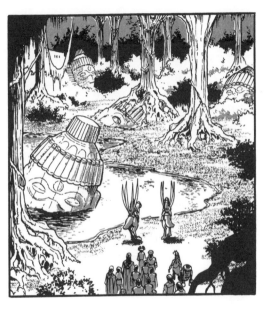

The Gungan soldiers led the newcomers to the ruins of a grand temple with massive stone heads scattered about.

Queen Amidala stepped forward to answer for him. "I am Queen Amidala of the Naboo. I come before you in peace."

Boss Nass gurgled. "Naboo biggen. Yousa bringen da Mackineeks. Yousa all bombad."

Amidala persevered. "We wish to form an alliance—"

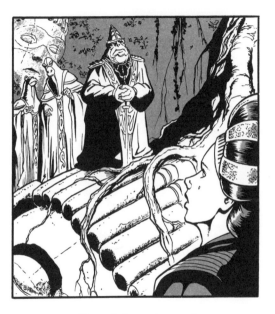

"I come before you in peace."

Suddenly, Padmé the handmaiden stepped forward, interrupting the Queen. "Your Honor . . ."

Boss Nass looked at the handmaiden. "Whosa dis?"

Padmé said, "*I* am Queen Amidala." She pointed to the woman dressed as Queen. "This is my decoy. My loyal bodyguard."

Anakin was stunned. The woman

*"I am Queen Amidala. This is
my decoy. My loyal bodyguard."*

he had called an angel, the woman he thought was only a handmaiden—she was the true Queen!

Padmé went on: "I am sorry for my deception, but it was necessary to protect myself. Although we do not always agree, Your Honor, our two great societies have always lived in peace. The Trade Federation has destroyed all that we have worked so

The woman he thought was only a handmaiden—she was the true Queen!

hard to build. If we do not act quickly, all will be lost forever. I ask you to help us . . . no, I beg you to help us."

Padmé dropped to one knee. "We are your humble servants."

Surprised, Boss Nass stared at her. Then he laughed and said, "Yousa no tinken yousa greater den da Gungans. . . . Mesa like dis. Maybe wesa bein friends."

Padmé dropped to one knee. "We are your humble servants."

✳ The next morning, the surface of the Otoh Gunga lake was smooth as a sheet of transparisteel. Around the shore, not a single creature stirred.

Then, suddenly, a great creature rose out of the swamp, shedding a great tent of water as it rose. Then came another, and another. They were enormous fambaas, bearing shield generators on their backs. Around their feet,

Suddenly, a great creature rose out of the swamp. Then came another, and another.

an army of Gungans marched in ordered ranks of footsoldiers and cavalry mounted on kaadu.

The Gungan army was on the march against their invaders.

As the Gungans reached the edge of the swamp and started out onto the grassy plains of Naboo, a smaller force crept into the palace of Theed. Padmé, her handmaidens, and the Jedi moved

toward the main hangar, with Anakin and the droid R2-D2 in tow. A few meters short of the entrance, they waited. Great as it was, the Gungan force was no more than a ruse. The real attack would be quiet and precise. Padmé planned to capture Viceroy Gunray. At the same time, she would free her pilots, who would then attack the Trade Federation's droid control

ship. If that were destroyed, the droid army would be paralyzed.

⸬ Suddenly, blaster fire erupted on the far side of the palace. Battle droids went into high alert, rushing toward the fighting. Padmé nodded to Qui-Gon. Captain Panaka had done his job, creating a second, smaller distraction. The group moved forward into the hangar.

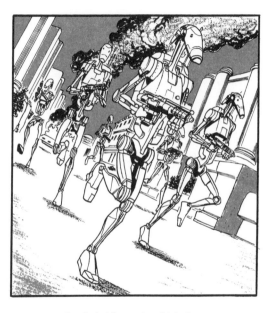

*Battle droids went into high alert,
rushing toward the fighting.*

✳ In the throne room, Nute Gunray called up a holographic image of the battle. "I thought the fighting was going to take place far from here. This is too close!"

Darth Maul growled, "There is more to this. The Jedi are involved." He turned and strode out of the room.

✳ The Gungans watched the tanks

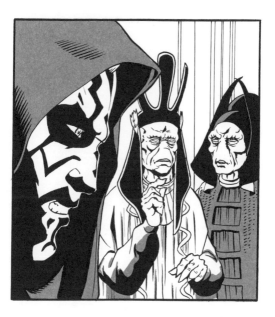

"There is more to this. The Jedi are involved."

of the droid army assemble. The Gungan commander, General Ceel, shouted, "Energize the shields!"

Instantly, power beams shot out from the generators on each fambaa, linking with those to the right and left. An energy shield grew and spread like an umbrella until it covered the entire Gungan army.

Not a moment too soon. The

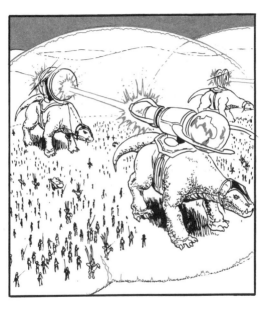

Power beams shot out from the generators on each fambaa, linking with those to the right and left.

Trade Federation bombardment fell just as the energy shield had formed. The Gungans sat impassively behind their shields as wave after wave of deadly energy beams sputtered against the powerful shield. The Gungans cheered.

OOM-9, the droid commander, watched without emotion. The energy shield was too strong to breach. But

—✳—————————————————

that shield, he knew, was only good against laser blasts.

OOM-9 issued a command, and the tanks halted their firing. The nose of each war wagon opened up, revealing racks of battle droids. The droids emerged from their storage bins by the thousands, then transformed into their upright battle modes.

As the droids neared the shield

wall, the Gungans powered up their weapons.

The first line of droids reached the energy shield and stepped through easily. The shield had no power to stop the solidly built war machines.

The Gungans opened fire. They hurled electropoles and flung energy balls. Catapults launched great globes of energy that splashed against the

*The first line of droids reached the
energy shield and stepped through easily.*

droids, causing them to short circuit. Hundreds of droids were destroyed in the fire blast.

Thousands more came on.

—✳— In the hangar, battle droids had detected the intruders and opened fire. Anakin dove under a parked Naboo starfighter as the firing began. The two Jedi tore through the droids as Padmé and her troops returned fire.

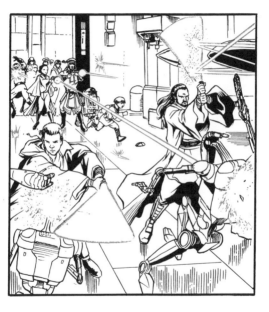

In the hangar, battle droids opened fire.

"Get to your ships!" the Queen ordered.

The Naboo pilots broke away from the rest of the troops and made for the fighters. "Better find a new hiding place, kid!" one of them yelled as she scrambled into the cockpit over Anakin's head.

Anakin looked around desperately as the fighter rose up and away,

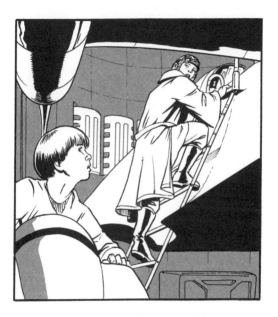

"Better find a new hiding place, kid!"

exposing him to enemy fire. Suddenly, he heard a loud whistle.

Artoo sat in the astromech droid socket of one of the remaining fighters. Anakin scrambled up and hid in the cockpit.

✳ Padmé and the Jedi fought the droids to a standstill, when suddenly new fire erupted behind the droids. Captain Panaka had broken through

the guards on the far side of the palace. His small diversionary force poured fire onto the destroyer droids, shattering the last of them.

The two small forces joined up, and headed for the throne room.

"Hey, wait for me!" Anakin yelled.

"No, Anakin," Qui-Gon said. "Stay where you are. You're safe there. Stay in the cockpit."

Anakin slumped back down.

✳ The Jedi and the Naboo rushed to the end of the hangar, intending to head straight for the palace. But as they reached a main doorway, their path was blocked by a figure shrouded in evil.

Qui-Gon knew he had been right. This was a Dark Lord of the Sith.

"We'll handle this," he said. He

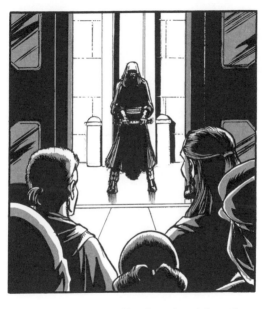

Their path was blocked by a figure shrouded in evil.

and Obi-Wan placed themselves between the Sith Lord and the Queen.

"We'll take the long way," the Queen said as she and the others moved off.

Darth Maul grinned eagerly. He drew his lightsaber. One end lit up, glowing blood red.

Then the other end lit up as well.

Centering themselves within the

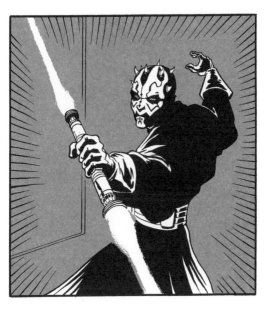

Darth Maul drew his lightsaber.

Force, the two Jedi waited as the Sith Lord lunged forward.

✳ From inside the fighter, Anakin watched the two Jedi cross laser swords with Darth Maul until Artoo's urgent bleeps caught his attention. He looked up to see ten destroyer droids wheel into the hangar bay and shift into battle mode, opening fire on Padmé's troops.

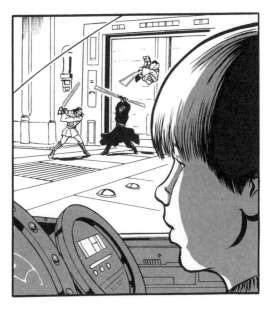

*Anakin watched the two Jedi cross
laser swords with Darth Maul.*

"Oh, no," he muttered. "We gotta do something, Artoo."

The droid bleeped. A moment later, the ship's systems went on line.

"Great idea! I'll take over!"

Anakin searched for the right button, and pressed it. Laser blasts burst from the fighter's nose, turning several destroyers into slag. In the confusion, Padmé and her troops bolted for the

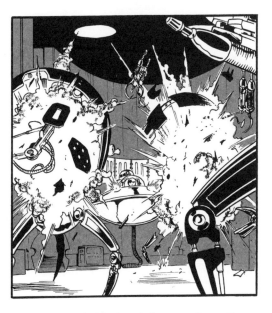

Anakin searched for the right button, and pressed it.

exit and raced deep into the palace.

✳ Artoo bleeped another warning as the destroyer droids identified their ship as the source of the laser fire.

"Shields up!" Anakin said, scrambling for the right controls. The shields went up, but then something roared behind them, and the ship lurched forward. Anakin's head slammed back against the headrest as

❋ ─────────────────────

the ship roared out of the hangar. "Whoops, wrong one!"

Artoo wailed. Anakin wailed back, "Oops! I didn't touch anything! It's on automatic pilot!"

The starfighter swooped up and out of the atmosphere, quickly gaining on a squadron of matching fighters racing toward the stars.

❋ Qui-Gon tried to keep the Sith

Lord occupied while Obi-Wan worked his way behind. But Darth Maul moved with laser speed, always keeping the two Jedi in front of him, spinning away whenever the Jedi got the advantage. Qui-Gon felt the strength in the Sith Lord's arm, strength enhanced by the fury of the dark side. He ignored it, and centered himself in the Force.

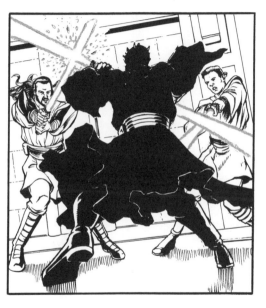

*Qui-Gon felt the Sith Lord's strength
enhanced by the fury of the dark side.*

─✳ The battle droid commander OOM-9 gave the signal to send in destroyer droids. Hundreds of droids rolled out of Trade Federation transports and through the Gungan's deflector shield, transforming themselves into deadly killing machines. The Gungans blasted the destroyer droids, but the Trade Federation droid army continued to move forward.

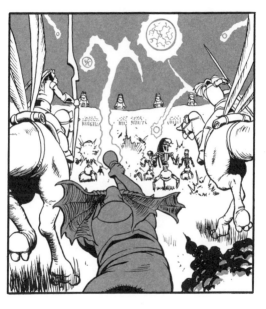

The Gungans blasted the destroyer droids,
but the army continued to move forward.

✳ In the lead fighter, Ric Olié was so intent on the Trade Federation battle-ship that he hardly noticed a stray friendly joining his squadron. He checked his coordinates and then growled into his comlink: "Bravo Flight A, take on the fighters. Flight B, make the run on the transmitter."

Before his co-leader could reply, "Copy, Bravo leader," a new set of

*"Bravo Flight A, take on the fighters.
Flight B, make the run on the transmitter."*

signals filled Olié's scopes. "Enemy fighters straight ahead!"

✳ "This is intense!" Blaster fire exploded around Anakin's starfighter. Artoo spat a stream of worried beeps. "Artoo, get us off of this autopilot. It's gonna get us both killed." Anakin searched for the readout that translated the droid's speech. "Yes, I've got control. You did it, Artoo!"

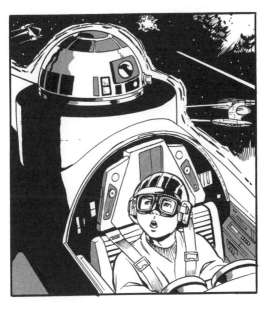

"Artoo, get us off this autopilot. It's gonna get us both killed."

✳ Darth Maul gloried in his power. With fierce thrusts, he drove the two Jedi backward, out of the hangar bay and toward a power generator. He saw an opening and kicked Obi-Wan off a catwalk. The Jedi fell to a lower level and hung by his finger-tips. But then Maul's overconfidence betrayed him. A slash from the older

The Jedi fell to a lower level and hung by his fingertips.

Jedi nearly took off his head, and the Sith Lord realized he had underestimated the Jedi. Drawing on the dark side, Maul leaped up to the catwalk above their heads and retreated into a long hallway. Qui-Gon followed, but he sensed the corridor pulsing with energy. They were in some sort of transfer station. High intensity energy beams shot from one wall to another,

then shut off, forming a series of deadly energy barriers separating the dueling men. Obi-Wan flung himself up onto the catwalk and followed.

Darth Maul rushed down several walls of the lethal rays before they activated again. Qui-Gon stopped short. One wall separated him from the Sith Lord. Through the Force, he felt Obi-Wan several sections behind.

There was nothing to do but wait.
✳ Captain Panaka, Padmé, and the Naboo soldiers reached the door to the palace throne room. Suddenly, two destroyer droids skittered in front of the door and two more appeared behind, trapping the Naboo. "Throw down your weapons," Padmé ordered. "They win this round."
✳ Out in space, the Naboo fighters

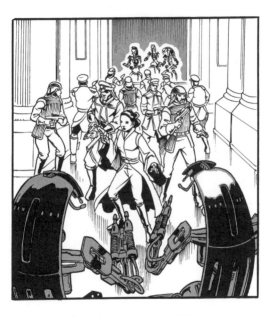

"Throw down your weapons," Padmé
ordered. *"They win this round."*

swarmed around the main battleship, but their weapons could not penetrate its shields.

Anakin dodged and jerked his ship this way and that, trying to avoid the blinding laser fire that flashed around him. An energy burst clipped his ship and sent him spinning out of control. Just as he regained direction,

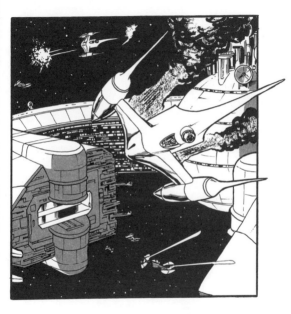

An energy burst clipped his ship
and sent him spinning out of control.

his fighter slid into the Trade Federation battleship's hangar bay. "We're hit! We're hit!"

A massive bulkhead loomed up in front of them and Anakin struggled to decelerate. The fighter skidded to a stop just short of the wall. He checked the controls. Every system was overheated. Anakin felt relieved for the two seconds it took him to realize a

—✳—

squad of battle droids was running in his direction.

✳ The energy ray cycled off. Qui-Gon moved faster than was humanly possible, attacking the Sith Lord ferociously. He drove Darth Maul to the end of the hall, to the edge of a melting pit that seemed bottomless.

Obi-Wan raced forward, trying to catch them. He pulled up short,

millimeters away from the end as the energy wall came alive again. He felt the deadly rays singe the hair on his forehead. Frustrated, he stopped.

The young Jedi could only watch as his Master and the Sith Lord fought. Darth Maul had recovered from the Jedi's initial onslaught, and he moved in for the kill. Qui-Gon

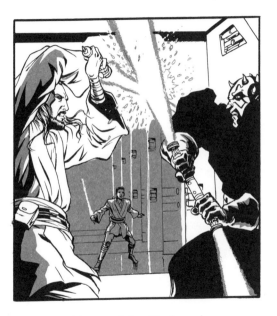

*The young Jedi could only watch
as his Master and the Sith Lord fought.*

countered, and the Sith whirled and struck again. Qui-Gon defended the first blow, but the second slipped past his guard. The Jedi Master fell.

"No!" Obi-Wan screamed. The energy wall fell, and he flew forward. Darth Maul deflected his attack easily.

✳ On the plains, the Gungans had been routed. Their small victories had done nothing to stop the onslaught of

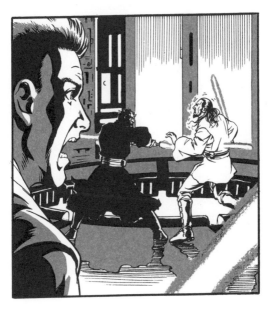

"No!" Obi-Wan screamed.

thousands of battle droids. Jar Jar was surrounded. "I give up! I give up!" he cried, his hands raised. Those Gungans who had not been captured were fleeing into the hills.

✳ Padmé, Captain Panaka, and the Naboo soldiers were brought before Nute Gunray, but one of the handmaidens dressed as the Queen distracted the Neimoidian, who sent the

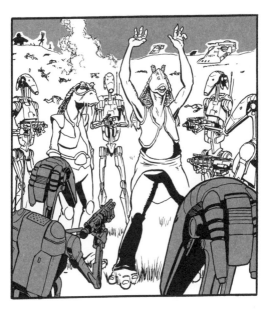

"I give up! I give up!"

battle droids after her. Padmé rushed to her throne to retrieve hidden blasters. "Now, Viceroy," Padmé declared, "this is the end of your occupation here."

※ Inside the power generator, Obi-Wan attacked Darth Maul with renewed fury. Machinery and chunks of metal flew about the room as he and

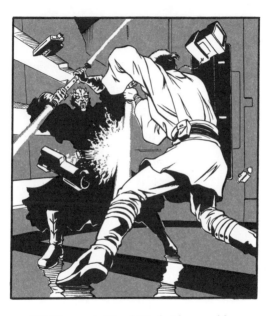

Obi-Wan attacked Darth Maul with renewed fury.

the Sith Lord used the Force to hurl objects at each other. Then Maul drove Obi-Wan backward toward the pit. Falling, at the last second, Obi-Wan managed to catch hold of a nozzle in the wall. His lightsaber continued to fall into the depths.

⁕ "This is not good," Anakin said. Battle droids surrounded his ship. He ducked down and out of sight. The

systems were still overheated, which meant he was helpless.

The lead battle droid looked up at Artoo. "Let me see your identification!"

Tucked in the cockpit, Anakin saw the system lights flip from red to green. "Yes! We have ignition!"

The ship lurched off the floor as the repulsors came on line. The shields

came up just in time to deflect the battle droids' weaponry. Anakin reached for his own firing systems and a dozen battle droids exploded into bits of shrapnel.

"And take this!" he shouted, pressing another switch.

Two torpedoes shrieked out of the fighter's nose. But they missed the droids and hurtled down the length of

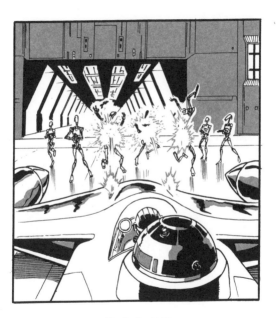

"And take this!"

the hangar bay. Anakin watched them veer sharply off course, searching for a target . . . and lock onto the largest power source in the ship.

The main reactor. Two small explosions flashed in the distance. They were followed by another, larger explosion, that shook the entire ship.

"Artoo, let's get out of here!" Anakin yelled.

"Artoo, let's get out of here!"

Artoo bleeped in agreement. Anakin turned the ship around and gunned the engine, ripping his way out of the ship as fire engulfed the hangar bay. Seconds later, the battleship exploded like a sun gone nova. "Now *this* is Podracing!"

✳ The Sith Lord smiled as he went in for the kill. But Obi-Wan had used the Force to fling himself up and out

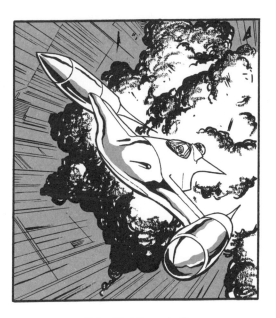

"Now this is Podracing!"

of the pit, calling Qui-Gon's light-saber to his hand. Seeing his opening, Obi-Wan attacked with a vengeance, cutting Darth Maul down. The Sith Lord staggered backward and fell into the pit, his body severed in two.

Obi-Wan rushed to Qui-Gon's side. "Master!"

Qui-Gon gasped. "It's too late. It's—"

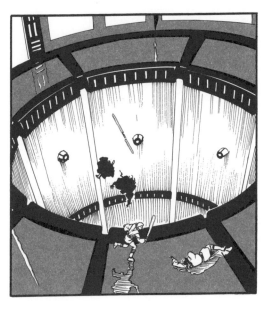

Qui-Gon gasped. "It's too late. It's—"

"No!" the young Jedi wept.

"Obi-Wan," the Jedi Master whispered. He felt himself slipping into the Force. "Promise . . . Promise me you'll train the boy . . ."

Obi-Wan blinked away tears. "Yes, Master . . ."

"He is the chosen one. . . . He will . . . bring balance . . . train him!"

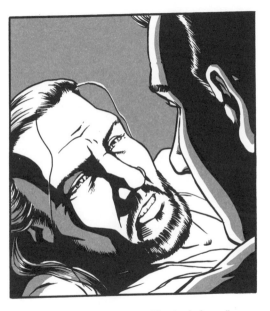

"Promise…Promise me you'll train the boy…"

Qui-Gon Jinn passed away as Obi-Wan Kenobi cradled his body. ✳ Suddenly, on the battlefield of Naboo, the battle droids froze. The Gungans paused, waiting to see what they would do.

But the battle droids did not move again.

Jar Jar inched forward to the nearest droid. He touched it. It didn't

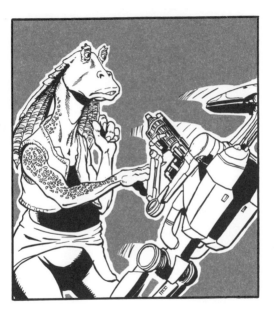

Jar Jar inched forward to the nearest droid.

react. He pushed it over, and it top-
pled into the grass. The Gungan
scratched his head. "Weirding."

✳ Sunset. Flames rose from the steps
of the Naboo funeral temple. Hun-
dreds of Naboo, along with Jar Jar and
twenty Gungan warriors, watched
with Obi-Wan and Anakin as the
funeral pyre of Qui-Gon Jinn burst
into flame. Anakin choked back tears.

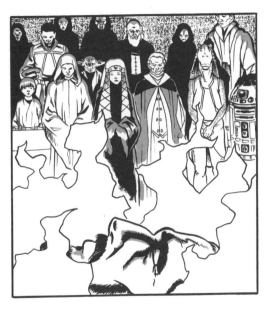

Flames rose from the steps of the Naboo funeral temple.

Obi-Wan put a hand on the boy's shoulder.

"What will happen to me now?" Anakin asked.

"You will become a Jedi," Obi-Wan replied. "I promise."

THE END

"You will become a Jedi. I promise."

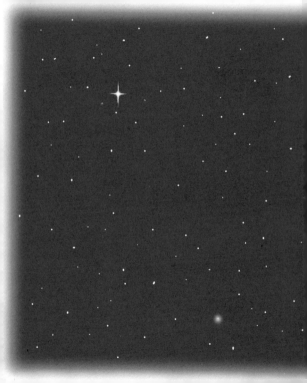